simply artistic

by Joan Chambers and Molly Hood

Alexandra.

First published in 1988
Reprinted 1990
BELAIR PUBLICATIONS LTD.
P.O. Box 12, Twickenham, England, TW1 2QL.
© Joan Chambers and Molly Hood
Designed by Richard Souper
Photography by Kelvin Freeman
Typesetting by Tameside Filmsetting Ltd.
Printed and Bound in Hong Kong by World Print Ltd
ISBN 0 947882 08 1

Distributed By:
Incentive Publications, Inc.
3835 Cleghorn Avenue
Nashville, TN 37215-2532
USA

Acknowledgements

The Authors and Publishers would like to thank the many children whose artwork has been photographed for this book.

Contents

- The purpose of this book is to present to teachers and parents simple art ideas for children. All the materials used are so basic that they can be found in most school stock cupboards or can be easily acquired elsewhere.

- As practising teachers we have successfully tried and tested all these ideas with large or small classroom groups, but they are equally suitable for parents and children at home.

- We recommend that each lesson begins with a demonstration of the techniques to be used, and that the child is then allowed to complete the activity in his or her own individual way.

- The photographs illustrate examples of work created by children and are not intended as models to be copied.

- Most of the activities can be completed in one session.

- All the ideas can be adapted across the age range from 4–12 years (in particular, those which are more abstract).

- We suggest that the child draws his or her own outlines, making it unnecessary to use adult templates. With this in mind, some ideas are included at the back of the book which we hope will be helpful.

- We are sure you will enjoy the variety of ideas which will come from the children themselves, and hope you find this book a source of inspiration.

Joan Chambers and Molly Hood

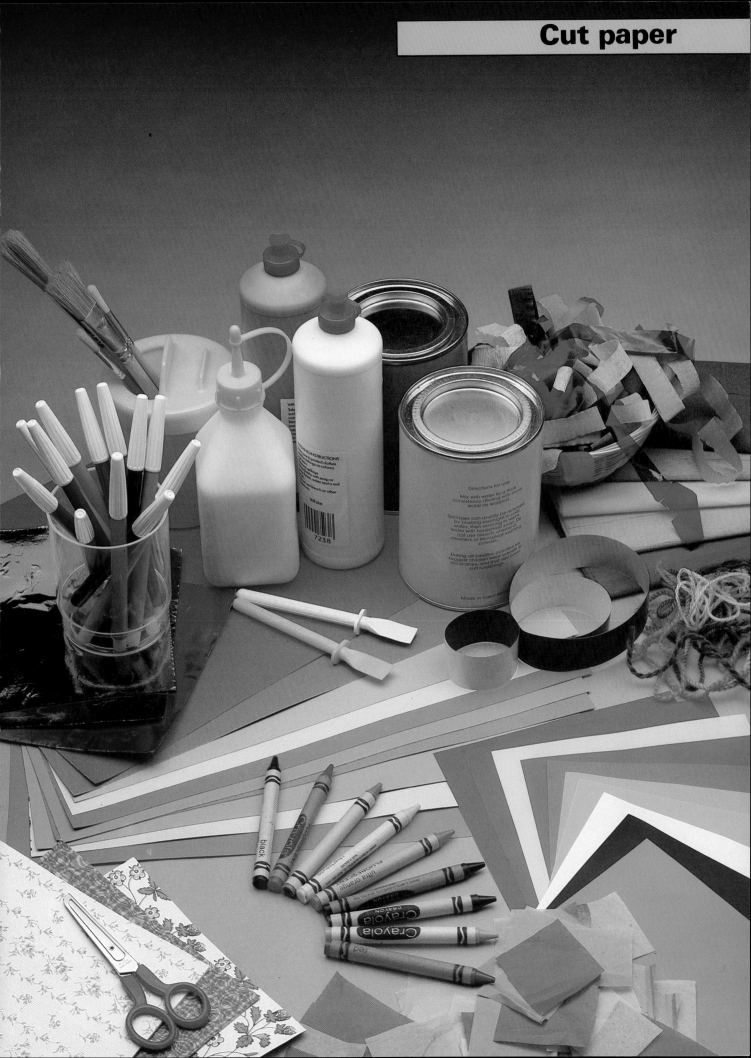

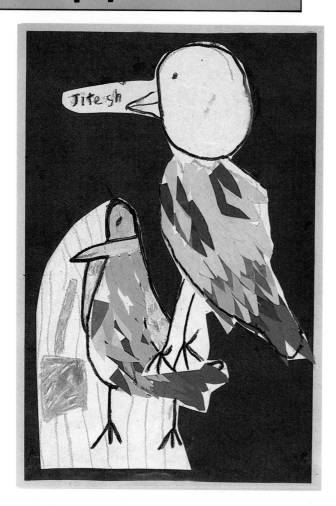

Feathered birds

You will need:

White paper for background
Strips of coloured gummed paper
Scraps of gummed paper
Felt-tip pens
Scissors and glue

Method:

1. Fold a long strip of paper several times, concertina fashion.
2. Draw, then cut out, a feather shape through all the thicknesses.
3. Repeat with other colours as necessary.
4. Discuss simple bird shapes and demonstrate.
5. Draw a large bird on the background paper.
6. Start at the bottom and glue feathers in rows, each row overlapping the next and glued only at the top. Cover any gaps.
7. Make a beak and legs from scraps. Make some long tail feathers using the feather technique.
8. Decorate and make into a picture.

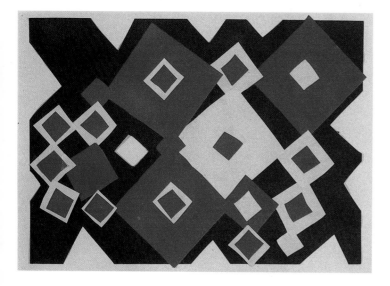

Squares only

You will need:

Black paper for background
2 pieces of brightly coloured gummed paper
Scissors and glue

Method:

1. Fold and cut the gummed paper into halves, quarters, eighths.
2. Arrange the various sizes of squares on the background by overlapping or touching at one point.
3. Glue down when arrangement is complete.
4. Add a third colour if desired.
5. Cut a pattern round the edge of the background.

Note:

● When glueing down the pieces, spread glue on the background first.

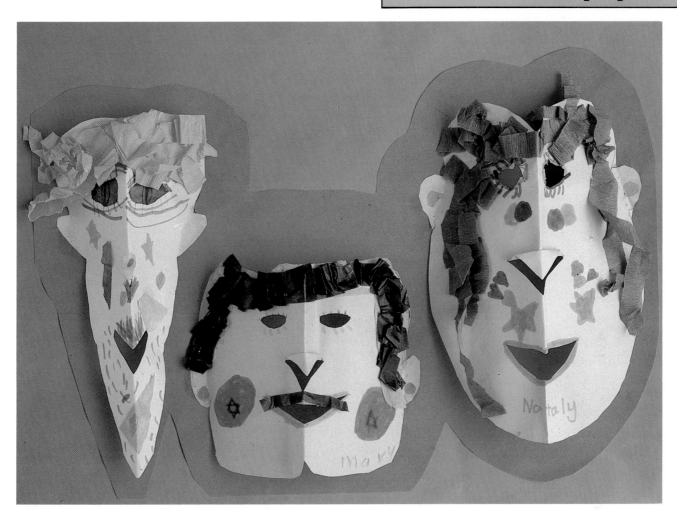

Wall masks

You will need:

Paper or light card—any colour
Felt-tip pens, paints
Scraps of wool, paper, foil, ribbon etc.
Scissors and strong glue

Method:

1. Show how to fold paper in half and draw the outline. (Demonstrate. Encourage children to use full width of paper.)

2. Cut outline of face, through both thicknesses.
3. Cut angled slit (nose) and fan-fold to stand out.
4. Cut out mouth and eyes while the paper is still folded in half.
5. Decorate with felt-tip pens (or paints) and scraps.

Note:

● Make some small masks from squares. Glue them one above the other to form a totem pole and use off-cuts to decorate.

● The masks can also be used for figures, e.g. clown, scarecrow, monster, by adding bodies and details.

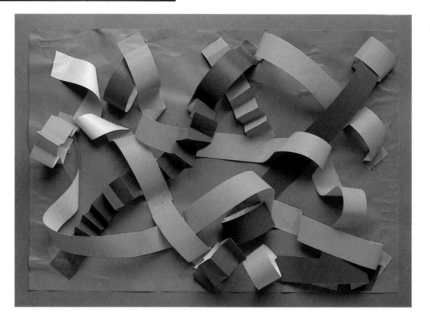

Over and under

You will need:

Brightly coloured paper for background
2 or 3 long thin coloured paper strips
Strong glue

Method:

1. Demonstrate how to make loops with a strip.
2. Demonstrate how to pleat a strip.
3. Place a blob of glue on the background and press down the end of one strip firmly.
4. Place blobs of glue all over the page and make loops. Repeat with other colours.
5. Make them go over and under each other where possible.
6. With an extra strip, experiment with other stand-out designs using shorter pieces.

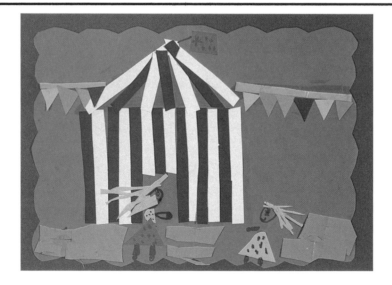

Circus tent

You will need:

Blue paper for background
Narrow strips of red and white gummed paper
Scraps of coloured paper
Scissors and glue

Method:

1. Discuss tent shapes. Demonstrate with drawings.
2. Glue the red and white strips carefully side by side to build up the base of the tent. Make a space for the door.
3. Match the strips to make the sloping top.
4. Cut flags from squares. Hang the flags on strings.
5. Decorate the background freely and make into a circus picture.

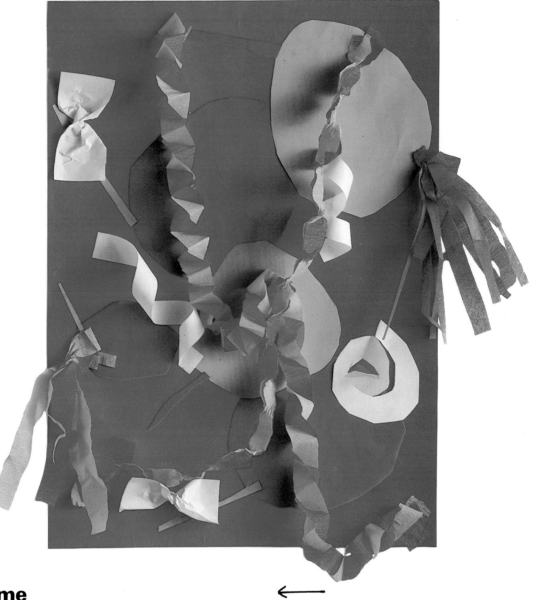

Party time

You will need:

Brightly coloured paper for background
Coloured strips of crepe
White paper
Coloured gummed paper
Scissors and glue

Method:

1. Cut out circles from the gummed paper and glue down to make balloons.
2. Twist some thin strips of crepe to make streamers.
3. Cut short white strips and twist these into bow shapes.
4. Cut more white strips and curl by rubbing the strip over a sharp edge, e.g. scissors, ruler, or edge of table.
5. Make streamers by pasting two strips of the crepe paper together at one end to form an angle of 90°. Keep folding the strips over each other.
6. Glue all decorations onto the background.
7. Cut some thin crepe strips and twist together at one end to form a bunch. Glue down.

Note:

- This can be made as a very large wall picture to celebrate birthdays, anniversaries, special events, by adding appropriate labels, e.g. "Happy Birthday, Peter".
- Figures can be added to complete a party scene.

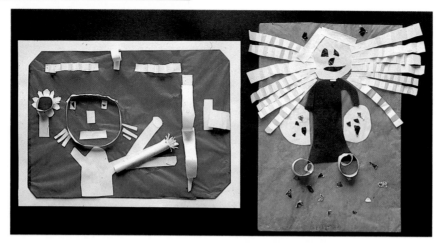

Paper-skills

You will need:

A piece of paper for background

Enough tissue to cover background and overlap all around

Thin strips of white or coloured paper

Scraps of white or coloured paper

Scissors and strong glue

Method:

1. Place the background paper on the tissue. Glue around edges of the background paper and fold the tissue over, turning the corners in.

2. Turn the paper over. Make a free pattern using the strips of paper in any way you wish. Some could be pasted edge-on to create a 3D effect. (e.g. rolling, fan-folding, splitting).

3. Finish with scraps of paper.

Note:

● Allow enough time, and spare paper, for practising paper skills.

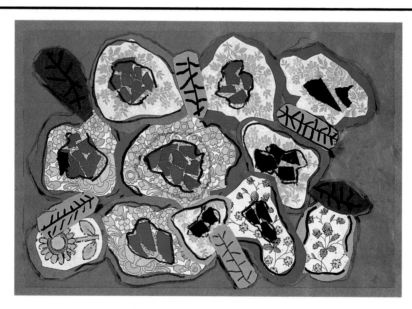

Wallpaper flowers

You will need:

Large piece of coloured paper for background

Pieces of patterned wallpaper

Brightly coloured paper for leaves and for mounting each flower

Felt-tip pens

Scissors and glue

Method:

1. Cut out medium-sized flowers of different shapes.
2. Mount each one on the coloured paper or card. Cut the mount to follow the shape of the flower, leaving an edge all round.
3. Make flower centres from scraps.
4. Glue each mounted flower on to the background, overlapping or leaving spaces. Add leaves and decorate with felt-tip pens.

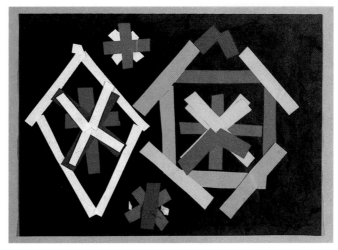

Speed patterns

You will need:

Black paper for background
Strips of gummed paper
Scissors and glue

Method:

1. Make a pattern by placing the strips on the black paper. Take them off again.

2. Experiment by placing the strips in several different arrangements.
 (For fun, set a short time limit for each attempt; say, one minute.)
3. Arrange a final pattern to cover the whole page. Glue the strips down. (It's easier to spread the glue over the page before making the pattern.)

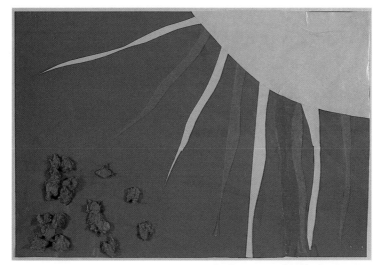

Sun picture

You will need:

Bright blue or black paper for background
Coloured gummed paper in red, orange and yellow
Scissors and glue

Method:

1. Discuss seeing the sun in space. Look at a whole sun, half sun and a quarter sun.

2. Cut one of the above shapes from the coloured paper and glue down on the blue background.
3. Demonstrate how to cut a flame shape.
4. Cut flames several at a time by holding pieces of paper together.
5. Tuck wide ends of flames under the sun.

13

Cut paper

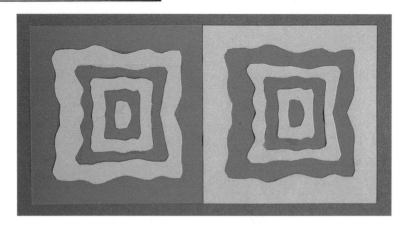

Jigsaws

You will need:

A piece of paper large enough to glue two squares of coloured paper side by side

Two contrasting squares of gummed paper

Scissors and glue

Method:

1. Place one square of gummed paper exactly on top of the other. Keep them together and fold them in half.
2. Hold the paper together on the open edges and cut a small shape out of the middle, on the fold. Keep

cutting around as many times as you can. Leave the outside shape with some of the fold.

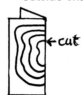

3. Glue the two outside shapes down on the background paper side by side.
4. Glue down colours alternately to fill in the spaces. Use all pieces of cut paper. Make sure the alternate shapes fit exactly before glueing down.

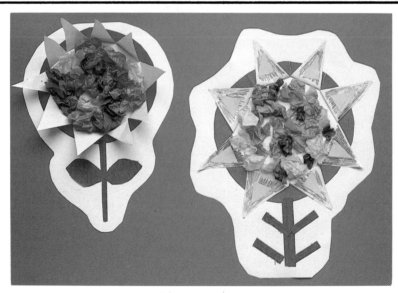

Star flower

You will need:

Paper for background

Coloured gummed paper

Scraps of tissue, crepe and foil

Felt-tip pens, scissors and glue

Method:

1. On the gummed paper draw around a circle shape and cut it out.
2. Fold the circle in quarters to find the middle.

3. Push the scissors through the centre point and cut along the folds *almost* to the edge (no further). Cut each quarter several times to make petals.

4. Press each section back to form the flower.
5. Glue the flower down and decorate the centre freely with the scraps.
6. Add stem and leaves to make into a picture.

Snowflake flower

You will need:

Brightly coloured paper for background
Square of brightly coloured gummed paper
Scraps of gummed paper in mixed colours
Scissors and glue

Method:

1. On gummed paper draw around a circle shape and cut it out.
2. Fold the circle in half, in quarters and then into eighths.
3. Cut small pieces out along the fold and from the point of the segment.

4. Open out and glue pieces of coloured paper scraps under the holes. Match the colours to make a symmetrical pattern, and add stem and leaves.
5. Glue onto background paper. Decorate freely and make into a picture.

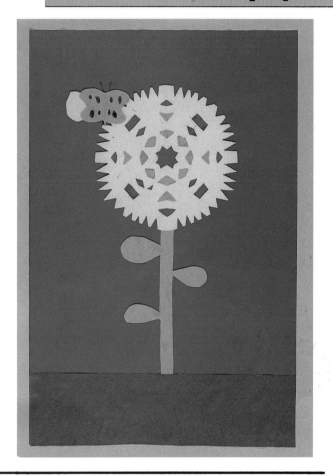

Opposites

You will need:

White paper or thin card in oblong shape for background
A piece of black paper exactly half the size of the white
Two pieces of black and white paper each about a quarter the size of the background
Black and white crayons
Scissors and glue

Method:

1. Glue the black shape onto half of the white background.

2. Hold the small black and white squares together and cut out shapes.
3. Glue them down in exactly the same place, white on black and black on white.
4. Make it into a scene on one side using crayons, then make the other side match.

Note:

● Try various colour combinations.

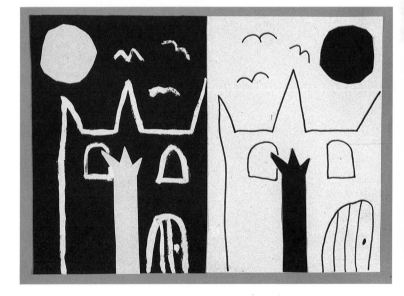

Cut paper

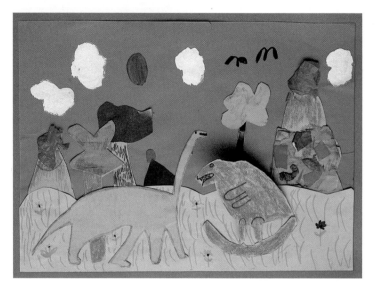

Dinosaurs

You will need:

Blue paper for background

Green paper approximately half the size of the background

Brown paper for volcanoes, dinosaurs

Coloured paper scraps, tissue, cellophane

Scissors and glue

Method:

1. Cut the green strip to make wavy hills and glue the base of the strip onto the background.
2. Cut volcanoes and trees then slip them in behind the hills, and glue down.
3. Draw and cut out dinosaurs. Colour them and add scraps of paper. Discuss ways to make the creature stand out from the background (e.g. glue pieces of folded card between the background and the dinosaurs).

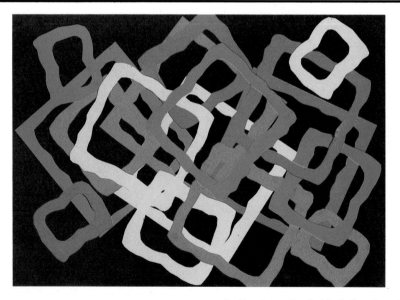

Frame pictures

You will need:

Black paper for background

Two squares of gummed paper—constrasting bright colours

Scissors and glue

Method:

1. Hold the pieces of gummed paper together and fold in half.

2. Cut into the fold, following the shape of the paper. Repeat this until all the paper is used.

3. Open out squares and arrange first into an overlapping pattern.
4. Glue shapes onto the background.

Paper sculptures

You will need:

3 pieces of paper the same size—in contrasting colours

Scissors and glue

Method:

1. Hold two pieces of paper together and fold down the middle. Open out and fold each half to meet in the centre.

2. Cut into each fold, one at a time, using straight and curved lines.
3. Open out carefully and cut along some parts of the folds. Flatten or roll back the others.
4. Glue these two sheets of paper together at the corners and glue on to the third sheet.

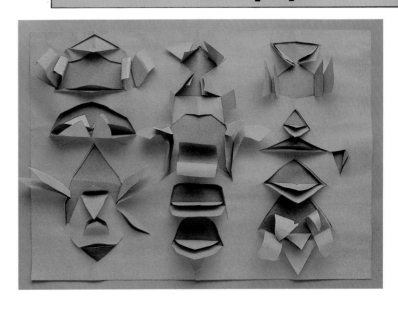

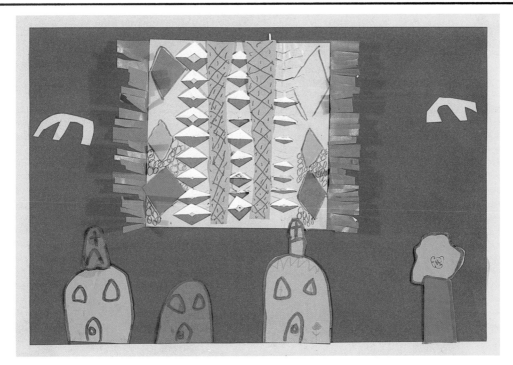

Magic carpet

You will need:

Coloured paper for background

Smaller piece of paper, preferably thin, in contrasting colour for a carpet

Scraps of coloured paper

Scissors and glue

Method:

1. Fold the smaller, thin piece of paper in half and in half again.

2. Make strong diagonal cuts along the folds.

3. Open out, and then bend alternate V-shaped pieces to form a pattern.
4. Decorate to make a patterned carpet and fringe.
5. Glue onto the background and make into a picture by adding houses, trees etc.

Cut paper

Ski jumper

You will need:

Large piece of paper for background
Small piece of paper—any bright colour
Piece of white paper to fit across the background
Narrow strips of coloured gummed paper
Scraps of coloured gummed paper
Felt-tip pens and crayons
Scissors and glue

Method:

1. Fold brightly coloured paper in half and draw jumper shape.

2. Hold the paper firmly while cutting along the line, open out and decorate with strips.
3. Glue white paper (for snow) on blue background. Glue the ski jumper on the background and add details to make a skier.
4. Decorate with crayons and felt-tip pens to make a ski scene.

Note:

● Try making football shirts, T-shirts and theatre costumes.

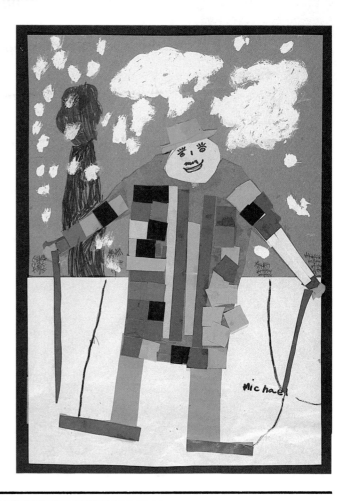

Triples

You will need:

3 squares of coloured paper
Contrasting paper for background
Scissors and glue

Method:

1. Draw shapes all over one square.
2. Hold the three squares of coloured paper together and cut out the shapes.
3. Arrange the shapes in threes all over the background then glue down.

Note:

● Looks effective when shapes are glued from a common point.

Tissue paper

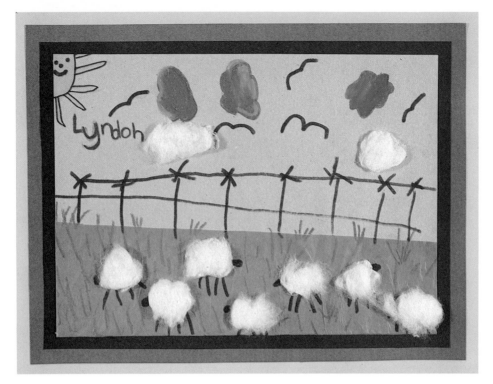

Farm picture

You will need:

Piece of paper for background—pale colour

Green tissue paper—larger than background paper

Cotton wool, fur fabric, odd scraps, brown paper

Felt-tip pens

Scissors and glue

Method:

1. Cover the bottom half of the background paper with glue.
2. Cut the green tissue to look like the horizon (e.g. hills) and glue onto background. Fold and glue the surplus around the back of the paper.
3. Make fences using brown paper by cutting posts and laying horizontal strips across.
4. Glue down sheep, cows, horses and farmhouses etc. using cotton wool, fur scraps, or odds and ends.
5. Use felt-tip pens to add detail.

Note:

● Make sure the green tissue is large enough to overlap.

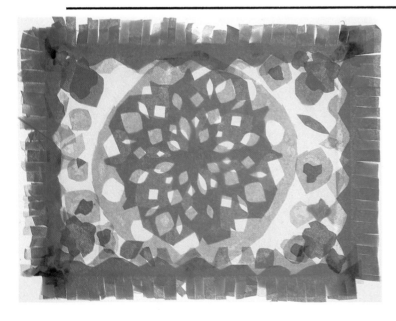

Tissue placemat

You will need:

2 pieces of tissue paper—placemat size

A selection of tissue paper in complementary colours

Scissors and glue

Method:

1. Cut out two snowflakes using complementary colours (see Snowflake Flower, p. 15) and glue on to one of the pieces of tissue.
2. Add the cut-out pieces for decoration.
3. Cut two contrasting strips of tissue together, fold in half, cut out a pattern along one side and glue along one edge of the mat.
4. Repeat on all edges.
5. Glue down the second piece of tissue over the first.
6. Fringe the edges.

Note:

● Can be used as a window picture.

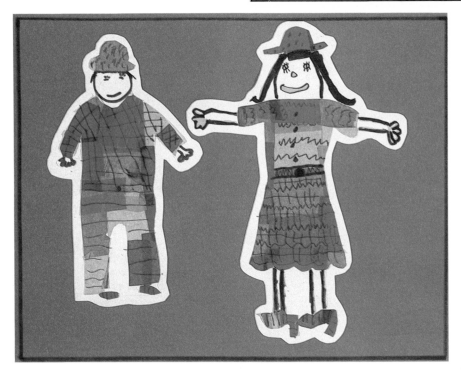

Patchwork people

You will need:

Paper for background

Coloured squares of tissue—about 1″ square

Scraps of card and paper

Felt-tip pens

Scissors and glue

Method:

1. Spread glue all over the background paper.
2. Stick squares of varying colours in overlapping rows. Cover the paper completely.
3. Turn over in order to draw a large garment.
4. Cut it out, and glue onto the background.
5. With felt-tip pens, make into a person and use left-over pieces to make accessories.

Note:

● This is effective for making quilts and buildings.

Snow picture

You will need:

White paper for background

White tissue paper—larger than background

Coloured and white tissue paper

Scraps of coloured paper

Felt-tip pens

Scissors and glue

Method:

1. Spread glue on the white background and crush white tissue on to it to form mounds.
2. Place a piece of large white tissue all over the picture and glue it over the mounds. Fold the surplus around the back and glue down.
3. Make figures, animals or trees in the snow from scraps.

Note:

● This method could also be used for grass, earth, mountains or making an island. The mounds must be reasonably small, or they will be awkward to cover.

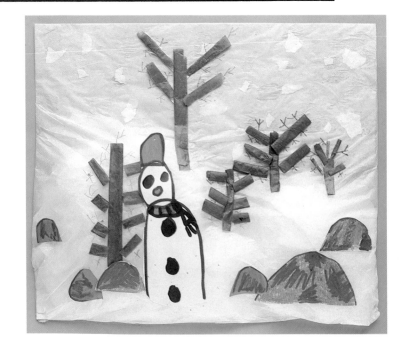

Tissue paper

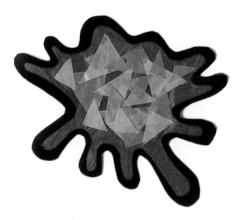

Window shapes

You will need:

Stiff black paper

Large sheet of tissue paper

Smaller pieces of tissue paper in various colours

Scissors, glue and chalk

Method:

1. Using chalk, draw a large shape on the black paper and cut it out.

2. Draw an inner line following the shape, and cut along this to form a frame.
3. Spread glue all over the frame and lay the tissue sheet on top.
4. Cut the smaller pieces of tissue and glue on to the central shape.
5. Trim when dry.

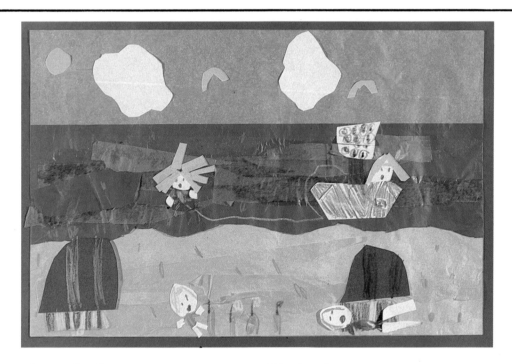

Sea, sand and sky

You will need:

White paper for background

Tissue paper in green, blue, yellow and orange, cut into strips wider than the background

Scraps of coloured paper

Scissors and glue

Method:

1. Draw the horizon. Spread glue over the paper and then fill the sky with overlapping strips of blue tissue paper.
2. Repeat with the sand and the sea using appropriate colours.
3. Make into a picture using coloured scraps for people, boats, shells etc.

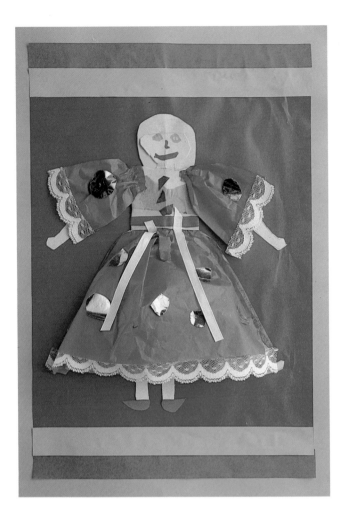

Dressing dolls

You will need:

Lightweight cardboard or stiff paper
Coloured tissue paper
Coloured paper for background
Scraps of ribbon, foil, gummed paper
Scissors and glue

Method:

1. Demonstrate how to fold paper and draw half a figure. Cut this out, starting at the fold.

2. For a skirt, cut out a rectangular piece of tissue paper. Gather or pleat it at the top and glue onto the waist.
3. Make the top and decorate it. Tissue paper can be gathered to make sleeves.
4. Make a belt and glue it round at the back to secure the clothes.
5. Glue the figure onto the background, add features and decorate freely with scraps. Glue the skirt along the sides to make it stand out.
6. One way of making hair is to cut out a shape from coloured paper larger than the head. Fold and slit it one-third of the way down. Open out and insert head through the slit.

7. Decorate the background.

Note:

● This technique could be used to make national costumes and fairytale or historical characters.

Seascape

You will need:

Blue paper for background
Tissue in sea colours—blues, greens and white
Small rectangle of white paper
Felt-tip pens
Scissors and glue

Method:

1. Spread glue all over the background.
2. Tear or cut tissue strips and glue flat.
3. Cut the rectangle into two triangles and a small rectangle and glue onto the background to make a boat. Decorate with felt-tip pens.

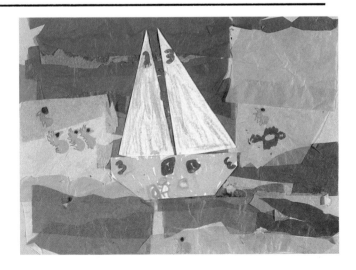

Spyglass picture

You will need:

Black paper for frame

Tissue paper—two colours

Gummed paper—any colours

Chalk

Scissors and glue

Method:

1. Discuss and demonstrate what is meant by 'horizon'.
2. Cut a large circle out of the black paper.
3. Fold in half, use chalk to draw inner circle. Keep folded and cut along the chalk line.
4. Open out and spread glue all over the ring frame. Lay one colour of the tissue paper approximately half-way up the glued ring, then the other colour to meet it (slightly overlapping). Press gently.
5. Decorate the horizon with chosen subject, e.g. a ship, island, aeroplane etc. When dry, trim away the tissue.

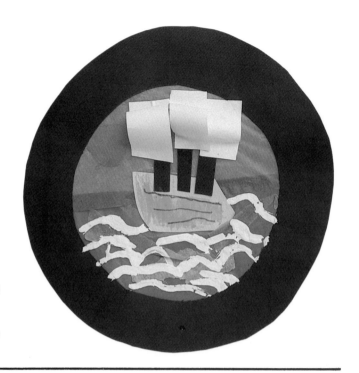

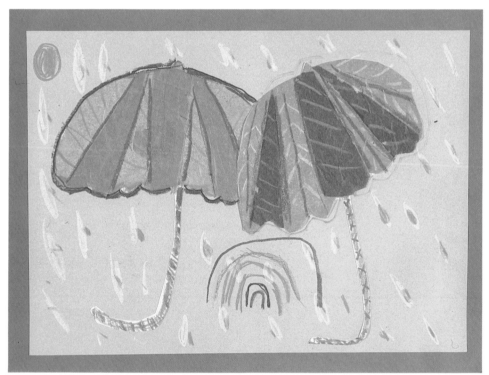

Umbrellas

You will need:

Coloured paper for background

Coloured tissue paper

White paper

Felt-tip pens

Scissors and glue

Method:

1. Draw a large umbrella. Demonstrate how to draw the spokes. Discuss use of umbrellas (e.g. rain or sun).
2. Glue a sheet of tissue paper over the umbrella shape. Other colours can be added to fit the sections.
3. Cut it out and glue it onto the coloured background.
4. Decorate with felt-tip pens and make a handle.
5. Draw rain and make into a picture.

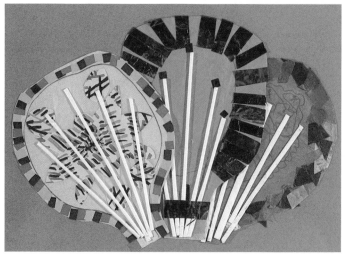

Straw fan

You will need:

Piece of stiff card

Tissue paper and scraps

Paper straws

Felt-tip pens

Scissors and glue

Method:

1. Fold the card in half and draw a half spade shape. Cut it out and open.

2. Spread glue all over the card and cover with a large piece of tissue. Repeat on the other side.
3. Glue the straws onto handle and spread out over the fan.
4. Spread glue around the edge and decorate with small torn pieces of paper.
5. When dry, trim with scissors and decorate with felt-tip pens.

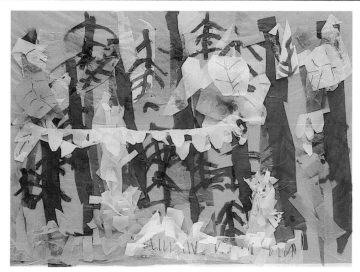

Forest scene

You will need:

Coloured paper for background

Tissue paper—pieces of black, brown, and shades of green

Felt-tip pens

Scissors and glue

Method:

1. Cover the paper with glue. Tear pieces of green tissue and glue down all over.

2. Make trees by cutting long thin shapes of brown and black tissue, or rolling tissue for trunks.
3. For foliage, fringe a strip of green, roll it up and pull up the centre. Glue onto background.
4. Cut or tear long pointed leaf shapes.
5. Attach leaves at both ends and make them stand out.
6. Draw leaf patterns with felt-tip pens and make vines by draping long thin twisted strips of tissue across the page.
7. Decorate freely to make a forest scene.

25

Tissue paper

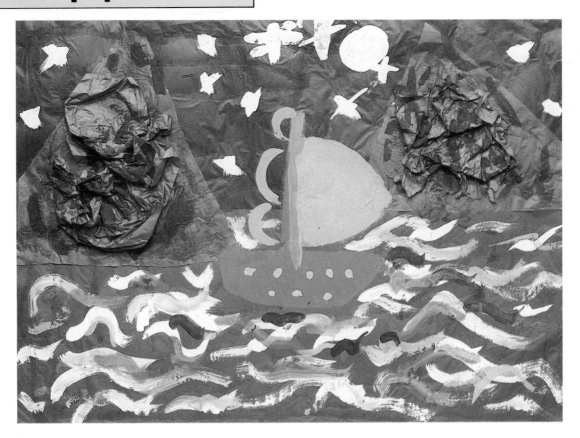

Tissue painting

You will need:

Piece of paper any size for background

Two different coloured pieces of tissue paper wider than the background

Scraps of tissue paper

Scraps of gummed paper

Paint and brushes

Scissors and glue

Method:

1. Discuss colours of sky and foreground.
2. Place a line of glue across the page to make a horizon.
3. Place the lower edge of the tissue sky on to the glue and flatten.
4. Glue on the foreground and flatten.
5. Turn the picture over, glue along all the edges and press down surplus tissue.
6. Turn over and complete the scene by painting and glueing on cut paper shapes and tissue scraps.

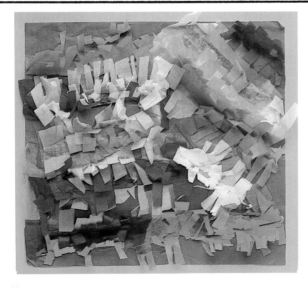

Fringing picture

You will need:

Coloured paper for background

Strips of tissue in various colours

Scissors and glue

Method:

1. Fold two strips of tissue (two different colours) together lengthways and fringe along the open side. Repeat the different combinations of colours.

2. Spread glue on the background paper and arrange strips to form a pattern, glueing as necessary.
3. Make the fringes stand out.

Mixed media

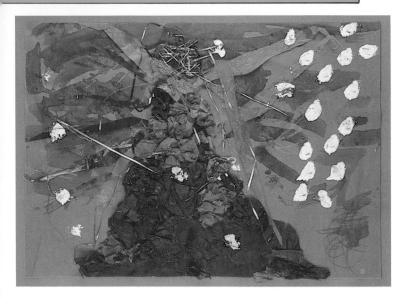

Volcano

You will need:

Large piece of paper for background
Pieces of dark coloured tissue paper
Strips of yellow, red and orange cellophane or tissue paper
Gummed paper scraps—brown and black
Paint—various colours
Brushes and small pieces of sponge

Method:

1. Draw a large volcano which comes half-way up the page.
2. Spread glue all over the volcano and build it out by glueing on loosely crinkled tissue pieces and gummed scraps.
3. Glue cellophane and tissue strips at the top of the volcano to give the effect of an explosion. Make some of them stand out by glueing the ends only.
4. Paint over tissue and background to create texture.
5. Print freely over the picture with sponge dipped in white paint.

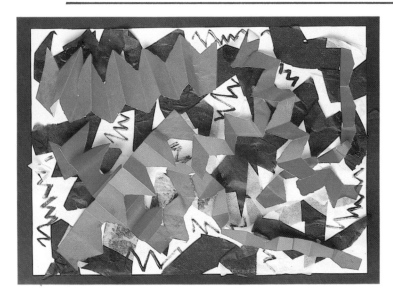

Zigzags

You will need:

Piece of paper for background
Strips of black and white tissue paper
Pieces of coloured gummed paper
Felt-tip pens
Scissors and glue

Method:

1. Fold the strips of tissue in half and half again.
2. Cut a zigzag pattern, then open out.

3. Cover the background with glue and arrange zigzags freely.
4. Fan-fold a sheet of gummed paper.
5. Cut across the folded sheet to make strips.

6. Repeat with other colour.
7. Glue strips onto the background and make them stand out.
8. Decorate with felt-tip pens in a zigzag pattern.

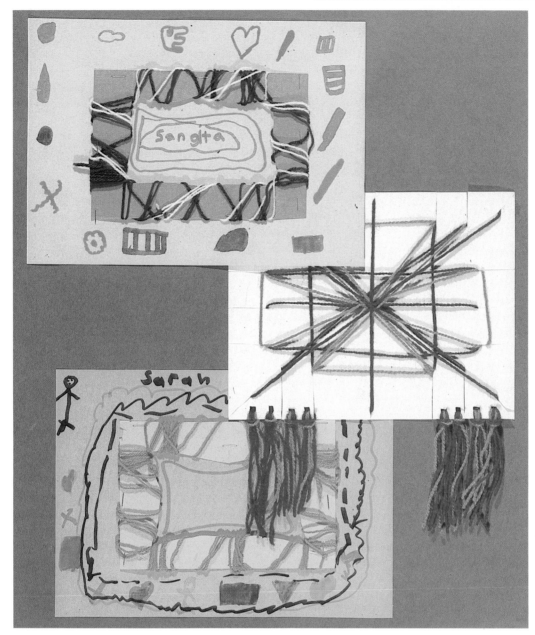

Cross-overs

You will need:

Squares or circles of card—medium thickness

Lengths of coloured wool or string

Felt-tip pens, crayons and pastels

Scissors and adhesive tape

Method:

1. Cut slits in the card. (If they are opposite each other the pattern will tend to be more regular.)

2. Tape the ends of the thread at the back and wind the wool to make a pattern.

3. Decorate the spaces in between with felt-tip pens etc.

4. To make a wall-hanging, add a loop and some tassels.

5. If desired, add interesting pieces (e.g. feathers) to the weaving before glueing it onto brightly coloured card.

Note:

● This is a good opportunity to learn to tie knots by joining short oddments of wool to make a length of various colours.

● These could also be used for calendars and gift cards. Try winding wool around a variety of shapes from which the centres have been cut out.

Mixed media

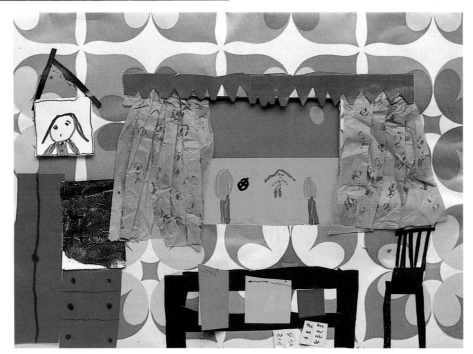

Curtain scene

You will need:

Piece of wallpaper with a strong pattern

Piece of paper slightly smaller than the wallpaper to make the whole picture firmer

Two pieces of tissue for curtains

Gummed paper in various colours

Felt-tip pens

Scissors and glue

Method:

1. Spread glue all over the smaller piece of paper and cover with wallpaper.
2. Fold over the edges of the wallpaper and glue down at the back.
3. Fold the wallpaper over and cut the window out symmetrically.

4. Pleat two pieces of tissue paper and glue onto the sides of the window to make curtains.
5. Glue gummed paper behind the window to make a scene and decorate the view with felt-tips.
6. Add furniture and pictures to complete the room scene.

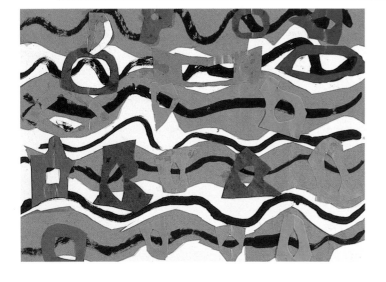

Wavy lines

You will need:

Paper for background

Coloured paper strips in two contrasting colours

Gummed paper

Thick black paint and thin brushes

Scissors and glue

Method:

1. Cut a wavy pattern along one edge of each strip. (Hold two together and cut at the same time.)
2. Spread glue all over the background and place strips alternately across the page, overlapping them.
3. Paint wavy lines across the page.
4. Cut rings from coloured paper and glue onto the painted lines at intervals. Other shapes can be used.

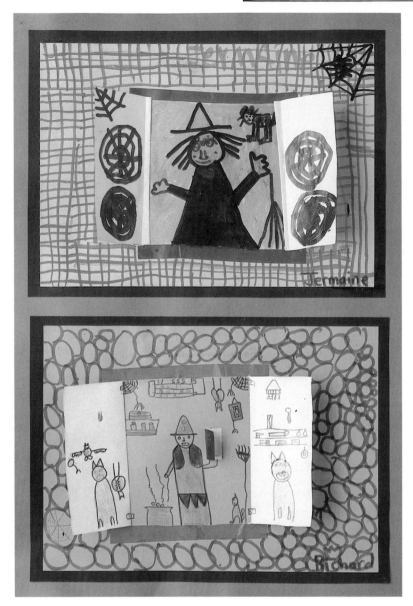

Window witches

You will need:

Pieces of stiff paper or coloured card for background

Squares of gummed paper—any bright colours

Scraps of coloured paper including black

Felt tip-pens

Scissors and glue

Method:

1. Fold the coloured square in half.
2. Make two cuts from the fold almost to the edge. Open out and cut along the fold.

3. Open the shutters and fold back.

4. Glue the window frame down in the middle of the card or paper. Leave the shutters free.
5. Discuss the type of house or castle the witch might live in. Demonstrate types of bricking.
6. Use a felt-tip pen to brick around the window. The same colour as the frame looks effective.
7. Make it into a picture with a witch at the window. Add cobwebs, bats etc.

Note:

● Other characters can be substituted, e.g. family, Father Christmas, animals.

● Create views of different rooms.

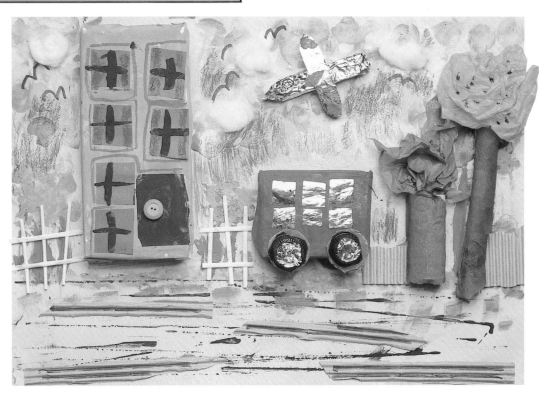

Junk picture

You will need:

Assorted boxes and other junk materials, i.e. bottle tops, lids, sticks, string, toilet roll centres etc.

Card for background

Scraps of coloured paper

Thick paint and brushes

Chalk

Scissors and strong glue

Method:

1. Paint boxes first.
2. Glue onto the background card.
3. Add other junk materials for detail.
4. Decorate the background with paint and chalk. Printing techniques can be used.

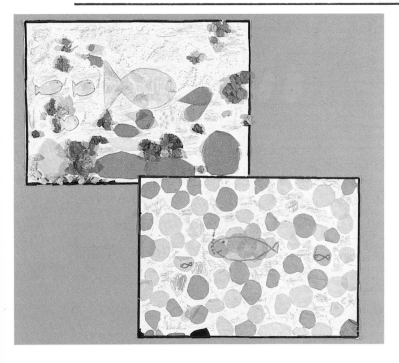

Camouflage scene

You will need:

Paper for background

Tissue scraps

Felt-tip pens

Scissors and glue

Method:

1. Discuss methods of camouflage used by wild animals and fish. Look at some pictures.
2. Draw an animal in its setting for camouflage.
3. Make the background using the tissue scraps by tearing, cutting, rolling or crushing them.
4. Complete the animal and blend the colours into the background. Decorate with felt-tip pens.

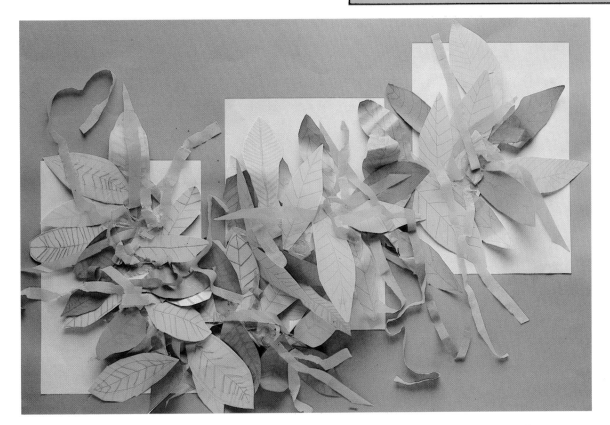

Vines

You will need:

Beige, brown or green light-weight card—large pieces

Green tissue paper, crepe paper and gummed paper

Pencils and felt-tip pens

Scissors and glue

Method:

1. Draw a long, winding branch across the card. Draw stems coming out along both sides. Cut it out.

2. Draw and then cut out lots of leaves. Glue them along the vine as they are finished.
3. Cut some strips of tissue paper and crepe, and glue them on the vine.
4. Make as many vines as required.
5. Use the vines for display by stapling at intervals and standing them out from the background.

Pattern picture

You will need:

Coloured or white card

Small scraps of fabric—cut into irregular shapes, all based on one colour, e.g. red and pink

Felt-tip pens and crayons

Strong glue

Method:

1. Decide on a colour theme.
2. Place a blob of glue on the back of each fabric piece.
3. Arrange them on the background with spaces in between and glue edges down.
4. Fill up spaces with patterns in crayon and felt-tip pens. Extra decoration on the fabric can be added.

Note:

● Sort the fabric into colour groups beforehand. This is an enjoyable activity on its own.

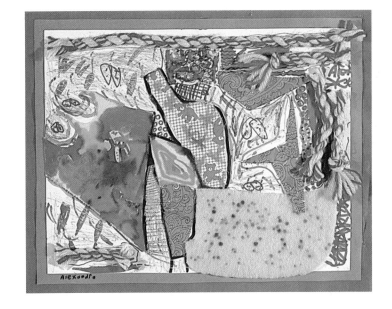

Robot mask

You will need:

A piece of medium weight card to fit around the head and deep enough to stand above the top of the head

Gold and silver spray or paint (black or grey would do)

Odd boxes, cartons, lids of bottles etc.

Scissors, strong glue and stapler

Method:

1. Measure a cylinder to fit comfortably over the head. Staple it and cut out a window for the face. It should sit easily on the shoulders.
2. Decorate to make buttons, panels etc. by glueing on odds and ends.
3. Paint or spray all over with chosen colour.

Note:

● This also makes an effective animal mask and can be used for fantasy themes.

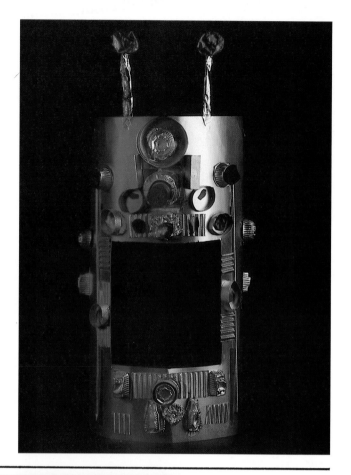

Colour mixing picture

You will need:

White paper for background

Paint—two primary colours

Gummed paper—same two colours as above

Long thin black strips of paper

Folded newspaper to use as a palette for mixing paint

Paint brushes—large

Scissors and glue

Method:

1. Cut the gummed paper into irregular shapes, (holes can be cut for greater effect) and glue at random onto the paper.
2. Mix the two colours on the newspaper palette and fill up the spaces on the paper (or paint the two colours directly on to the paper).
3. Glue black strips over pattern.

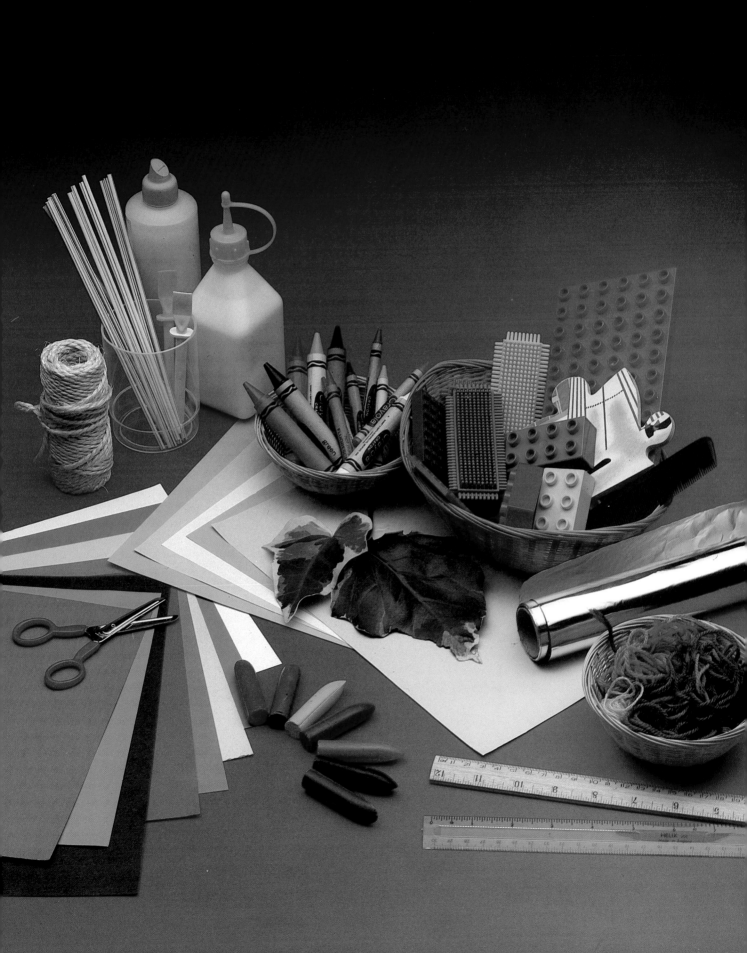

Rubbings

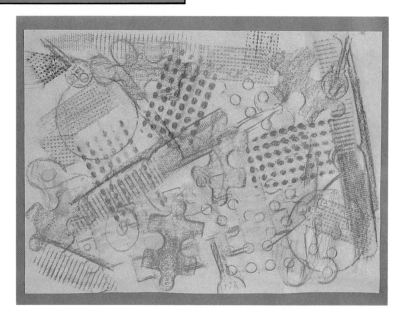

Everyday rubbings

You will need:

Thin, pale-coloured paper for the background

Coloured or metallic crayons—with papers removed

Pieces of jig-saw and other interesting surfaces for rubbing

White scrap paper

Method:

1. Experiment with the scrap paper. Place objects under the paper and rub over with crayons to see the different effects.
2. Now place the objects under the background paper and move either the shapes or the paper. Fill the page with the rubbings, using the side of the crayon.

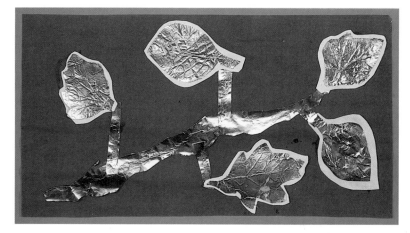

Foil leaves

You will need:

Black paper for background

White paper

Aluminium cooking foil

Leaves

Scissors and glue

Method:

1. Place leaf (vein side up) under a piece of foil (shiny side up).
2. Rub with fingers until whole leaf appears. Cut out carefully.
3. Glue onto white paper and cut around the leaf shape leaving an edge. Repeat.
4. Cut a branch from foil and glue onto black paper, adding stems and leaves.

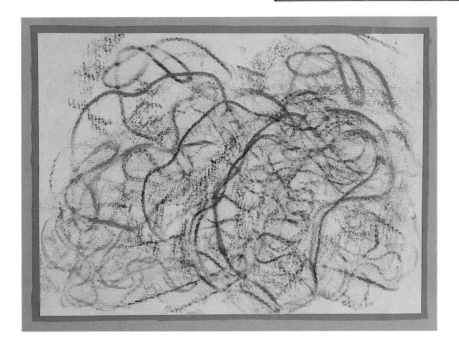

String and wool rubbings

You will need:

Sheet of thin paper

Various lengths of string and wool

Crayons with papers removed

Method:

1. Arrange wool and string in patterns on the table-top.

2. Lay the paper over and rub carefully with a crayon, holding the paper firmly with one hand.

3. Lift the paper and move it around and repeat the pattern.

4. Keep rubbing until the page is full. Use different coloured crayons and press hard to obtain strong colours.

Cut-out rubbings

You will need:

Thin paper in white or any pale colour

Scraps of card

Thick crayons with papers removed

Method:

1. Cut an irregular shape from the card. (There is no need to draw it first.)

2. Fold it and cut a smaller shape out of the fold.

3. Place both shapes under the paper and rub over them with the side of the crayon.

4. Move the shapes around to create an overall pattern.

5. Use different coloured crayons.

Note:

● Try using textured card, e.g. corrugated, to vary the effect. This method can be used for backgrounds on small or large-scale pictures to create grass, trees, buildings, pavements, roads.

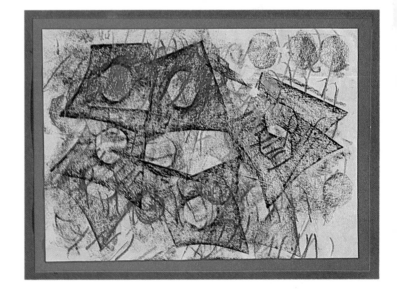

Rubbings

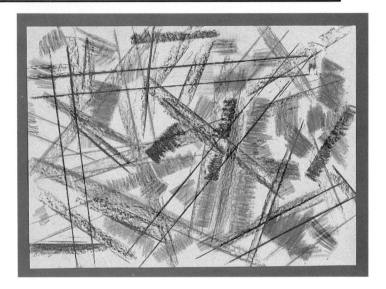

Ruler rubbings

You will need:

Thin paper—pale colour or white

Thick crayons—any colour

A ruler

Method:

1. Place ruler under the paper and rub firmly with crayon along both edges.
2. Move ruler to a new position and repeat several times.
3. Place ruler on top of the paper and hold firmly. With the point of the crayon rub out from the ruler's edge.

4. Repeat several times to complete pattern.

Grid patterns

You will need:

Thin coloured paper

Crayons—soft and thick

Small flat shape to rub, e.g. jig-saw

Plastic straws

Method:

1. Keep folding the paper in half until there are sixteen boxes. Open out.
2. Place the shape under the first box and rub.
3. Repeat using crayons in alternate colours to fill all the boxes, and to make a border.
4. Place the straws under the folds and rub to form a grid.

Alexandra

Fold-over rubbings

You will need:

Sheet of thin paper

Coloured crayons with papers removed

Method:

1. Fold each corner of the paper under and rub firmly, then open out to see the pattern.

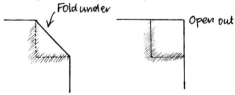

Fold under Open out

2. Fold under as many ways as possible and rub using different coloured crayons.

Note:

● This is very simple and effective as a means of practising rubbing skills with the minimum of equipment.

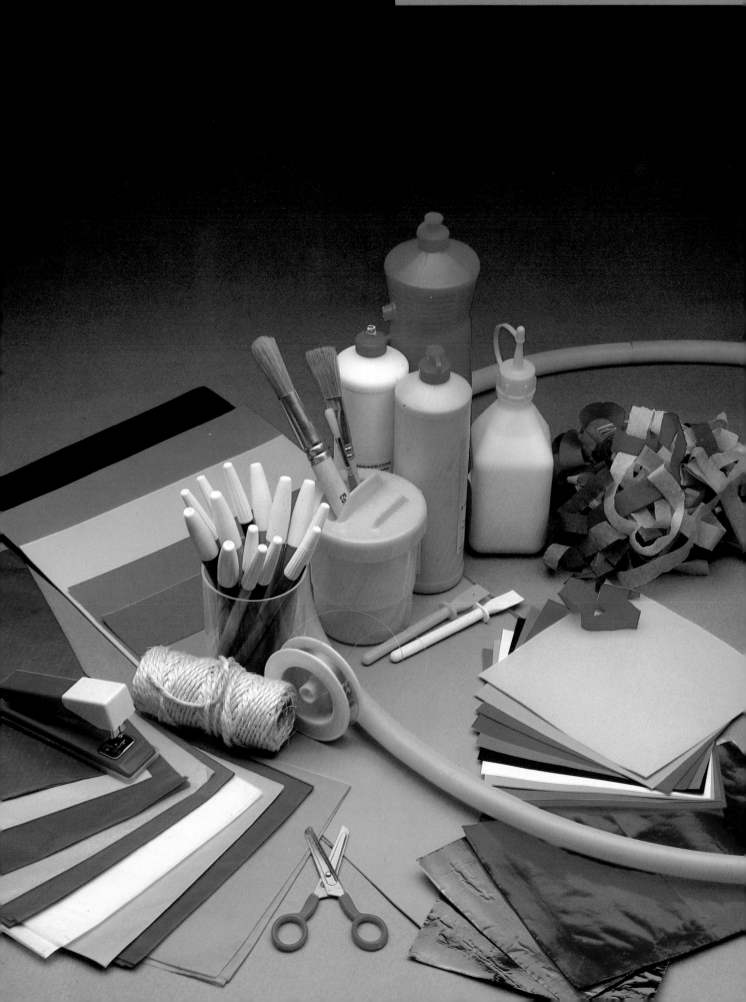

Mobiles

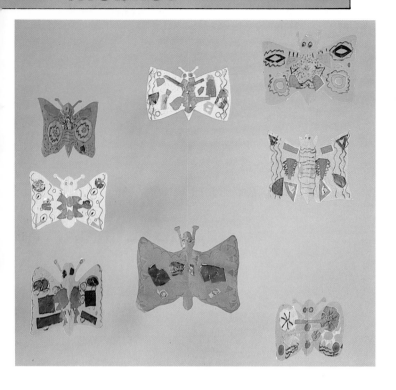

Butterflies

You will need:
Thin card
Two sheets of tissue paper in contrasting colours
Scraps of paper
Felt-tip pens
Scissors, glue and thread

Method:
1. Draw and cut out a circle from thin card.
2. Spread glue over one side and cover with a sheet of tissue. Repeat on the other side with a different colour.
3. Fold the circle in half and draw half a butterfly, making sure the body is on the fold.

4. Cut out the butterfly holding the two sides together.
5. Open out and decorate with tissue scraps and felt-tip pens.
6. Use thread to hang butterflies, one under the other.

Note:
● This method can be used for other shapes, e.g. animals, flowers, clowns etc.

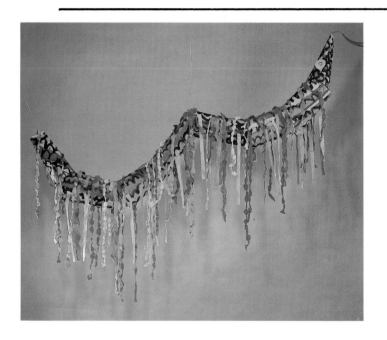

Snake

You will need:
8 pieces of white or coloured paper to make cylinders
Strips of coloured paper and coloured tissue
Brightly coloured paints and black paint
Scissors and strong glue or staples
String for hanging the finished piece

Method:
1. Paint each piece of paper in bright strips, horizontally or vertically.
2. When dry, add scale patterns in black or coloured paint.

3. Staple or glue the paper into cylinders.
4. Make one of the eight cylinders into a head and another into a tail by stapling or glueing into a pointed shape, then thread a string through the cylinders to assemble.
5. Add strips of paper to hang from mobile and decorate freely.

Note:
● This can be adapted as a rocket, dragon or caterpillar and makes a bright, effective mobile to hang across the room. (Make sure the cylinders are well glued or stapled before hanging.)

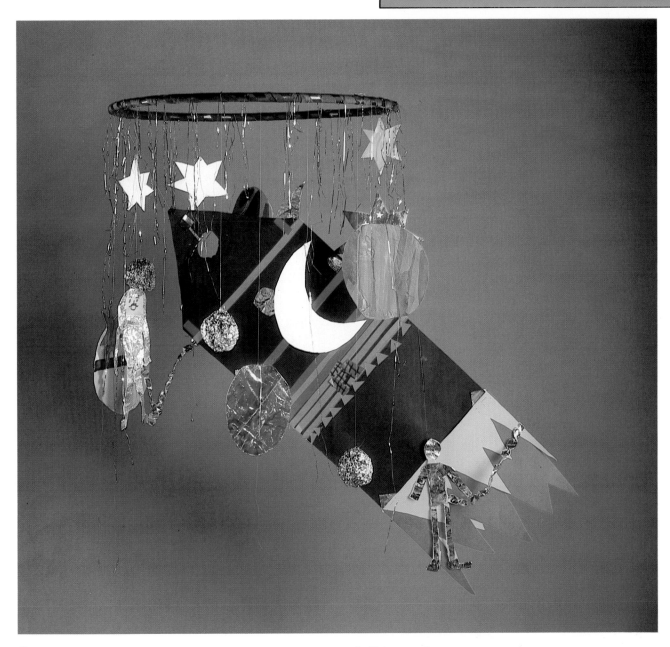

Space

You will need:

Large sheet of black card

Silver foil

Gummed paper, crepe paper, black tissue paper

Plastic hoop

Small pieces of red, yellow and orange card for flames

Scissors, glue and thread

Method:

1. Cut out a large rocket shape from the black card. Decorate it with coloured paper on both sides.
2. Cut out flames from coloured card and glue them onto the rocket.
3. Make astronauts from card and decorate with the foil. Attach astronauts to the rocket with lines of twisted crepe or foil.
4. Using card, cut out stars, planets, comets, moons etc. Decorate with foil.
5. Cover the hoop with black tissue. Hang the space shapes from the hoop at different levels. Suspend rocket from the middle.
6. Add strips of foil and black crepe or tissue to the hoop.

Mobiles

Underwater

You will need:

Strips of strong card—in bright colours if possible
Thin card
Gummed paper and wavy crepe strips in sea colours
Felt-tip pens
Scissors, glue and stapler
Thread

Method:

1. Staple some strips to make shapes e.g.

2. Draw and cut out sea creatures from thin card. Decorate with gummed paper.
3. Glue strips to mobile shapes and add sea creatures.
4. String together with thread to hang.

Note:

● These strip shapes can be used to display words, numbers, pictures or topic work.

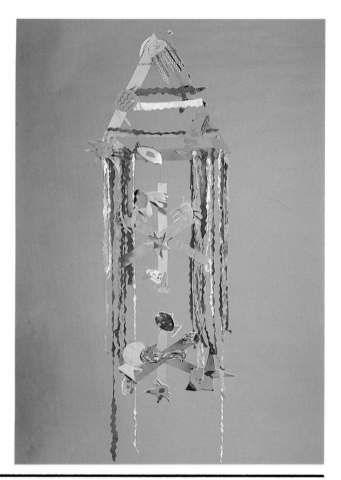

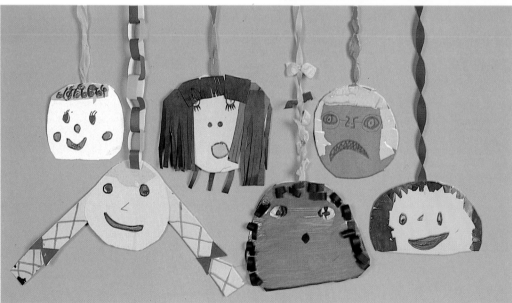

Faces

You will need:

Light-weight card in various colours
Gummed paper, tissue and coloured paper
Crepe paper strips in various lengths for hanging
Felt-tip pens
Scissors, glue and stapler

Method:

1. Draw circles freehand and cut out.
2. Decorate face with gummed paper and felt-tip pens.
3. Make hair by curling, rolling and fringing paper.
4. Decorate the back of the head.
5. Staple on coloured strips for hanging. (These can also be decorated.)

42

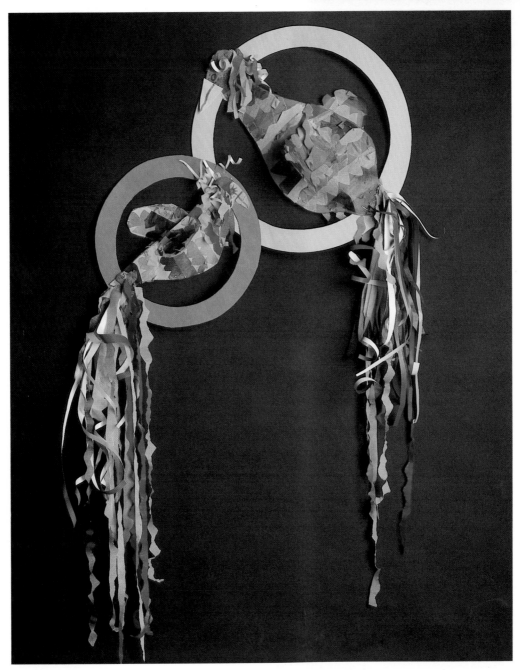

Rainbow birds

You will need:

Card, any colour

Strips of tissue and gummed paper in various colours

Paper tissues

Scissors and glue

Method:

1. Fold over a piece of card, draw a bird and cut out both thicknesses together.
2. Fold several strips of tissue together and cut out feathered shapes.
3. Starting at the bottom of one body shape, glue down feather strips to slightly overlap. Repeat with other body shape.
4. Draw and cut out two wings. Decorate in the same way as the body. Staple wings onto the two body shapes.
5. Leaving spaces for the head and tail feathers, staple the two body shapes together. Stuff with several tissues.
6. Take a bunch of thin strips of tissue and gummed paper and fit them into the tail space and staple. Repeat on the head.
7. Cut a ring from card. Staple the bird to the ring and hang.

Note:

● This technique could be used for fish, rocking horses, circus performers etc.

Mobiles

Easy shapes

You will need:

Stiff card in two colours
Circle shapes of various sizes to draw around
Thread
Scissors and strong glue

Method:

1. Cut out a selection of circles in various sizes.
 — Make one into rings by cutting out the centre.
 — Fold two circles in half and glue the two halves back to back.

glue

 — Make one circle into a cone by cutting to the centre and overlapping edges. Glue down.
2. Decorate all the shapes with spirals, small cones or any other circular ideas.
3. Hang different types of circles one under the other.

Note:

● Try using other shapes, e.g. squares, hearts etc.

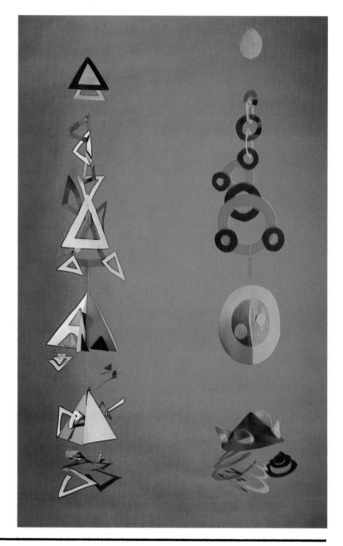

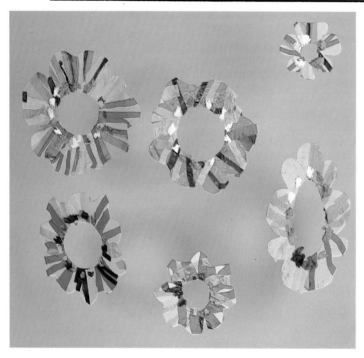

Hanging flowers

You will need:

Large sheets of coloured card
Long strips of tissue and crepe paper
Scraps of tissue paper
Scissors and glue
Thread

Method:

1. Draw a large flower with a circle in the centre. Cut out flower and the centre.
2. Spread glue on a small part of the flower, and wind strips around this section to overlap.
3. Glue some crushed pieces of tissue paper around the centre circle.
4. Hang the flowers singly, or one under the other.

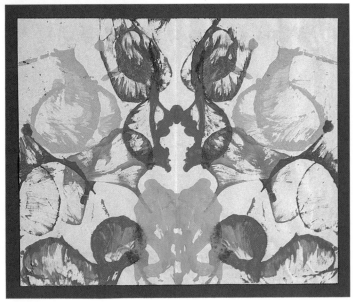

Pull-through prints

You will need:

A sheet of paper folded in half

Paint in small yogurt pots

Pieces of string

Method:

1. Lower string into paint, keeping hold of one end, and place on one half of the paper.

2. Keeping hold of the dry end, fold paper on top.
3. Press down with free hand and pull the string out. Open the paper.
4. Repeat with other colours, using separate strings for each.

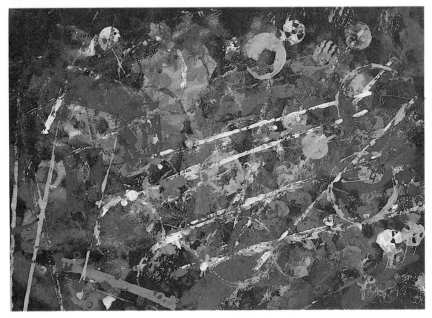

Fireworks

You will need:

Black paper for background

Paints in white and bright colours

Junk materials for printing e.g. rulers, boxes, sponges, cotton reels, plastic lids, straws etc.

Thick brushes for applying paint

Method:

1. Discuss how fireworks look in the sky at night.
2. Using the bright colours first, brush paint thickly onto the junk material.
3. Print all over the page using the junk material.
4. Leave white printing until last to keep the colour bright.

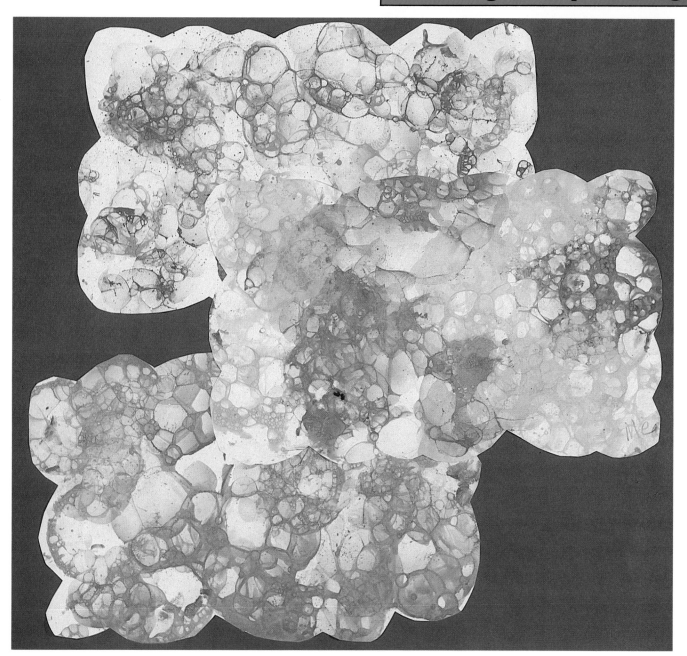

Bubbles

You will need:

Paper
Liquid detergent
Liquid paint (or mixed powder paint)
Drinking straws
Small containers e.g. yogurt pots

Method:

1. Half fill the container with a mixture of detergent and paint.
2. With the straw in the mixture, blow until bubbles overflow the container. (Use two straws at a time if necessary.)
3. Gently place the paper against the bubbles. Repeat using different colours.

Note:

● The circular effect of this pattern lends itself to making clouds, flowers, balloons and faces.
● Used in blues and greens it makes an attractive sea when cut out and overlapped.
● Used in dark colours it makes an atmospheric storm background.

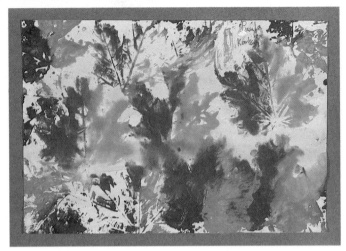

Leafy prints

You will need:

Paper for background

Leaves

Thin paint for wash in two colours

Thicker paint in two colours

Method:

1. Apply the wash in strips of colour to cover the whole page.

2. Paint over a leaf, half in one colour, half in the other.

3. Print the leaf onto the wet background and repeat all over the page. (Different leaves can be used for variations in pattern.)

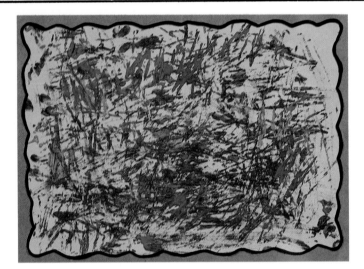

Printing rollers

You will need:

Paper

String or wool

Toilet roll centre packed with newspaper

Paintbrushes

Thick paint in complementary colours

Adhesive tape

Method:

1. Tape one end of the string to the toilet roll centre and wrap around (making sure there isn't too much string in one place). Tape down the other end.

2. Brush on paint and print by pressing or rolling all over the page.

3. Repeat using the other colours.

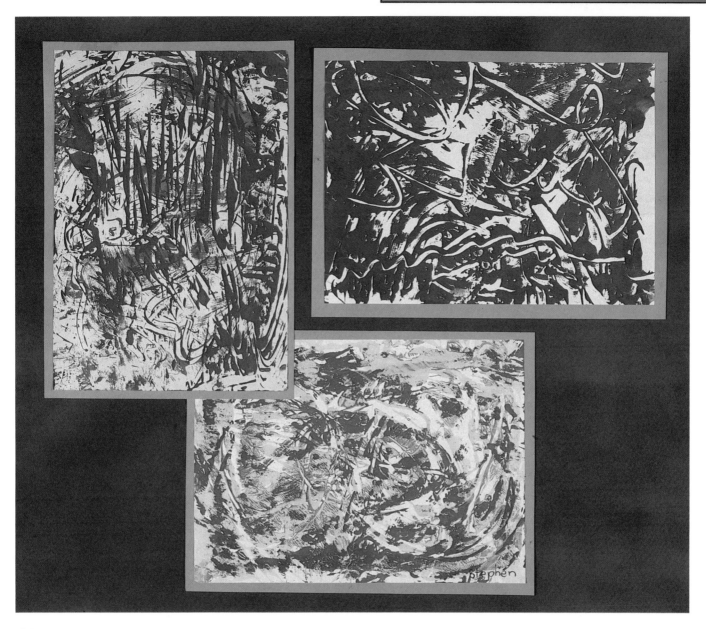

Shaving cream print

You will need:

Pale coloured or white paper for background
Tin of shaving cream
Liquid paint—various colours
Piece of laminated board or table-top

Method:

1. Squirt some shaving cream onto the board or table-top.
2. Add one light colour (e.g. yellow) and mix in equal quantities with the shaving cream.
3. Create patterns using hands or brushes.
4. Press a sheet of light coloured paper onto the mixture and carefully lift.
5. If desired, add another colour e.g. blue, and repeat step 4, with the same paper.
6. Repeat as often as required using different colours.

Note:

● Allow plenty of time for finger painting between prints.
● Try different combinations for colour mixing purposes, e.g. red/white, yellow/blue, red/blue, or perhaps leave some as mono-prints.
● These make interesting textured backgrounds for fire, sea, forest or space pictures.

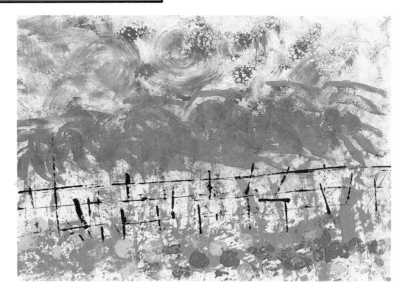

Speedy landscape

You will need:

Large piece of paper for background

Paint in shallow containers (seasonal colours, if relevant)

Crumpled newspapers, tissue paper, sponges, rulers, boxes, corks etc.

Method:

1. Discuss sky and land colours.

2. Using sponges and newspaper, print foreground and sky. Use swirling and sweeping movements to create interesting effects.
3. Use other scrap materials to print details, e.g. mountains, trees, houses, fences.

Note:

● Ruler edges produce strong lines for trees and fences.

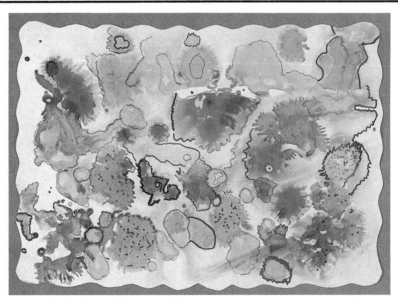

Wet painting

You will need:

Large sheets of good quality paper

Coloured paints—fairly thin

Water

Felt-tip pens and brushes.

Method:

1. Hold paper under a tap, or wet with a brush.

2. Drip colour on with a brush, and tip the paper from side to side.
3. Let the paper dry then outline the shapes with felt-tip pens.

Note:

● To make seascapes, landscapes or forests, first draw a horizon and choose appropriate colours.

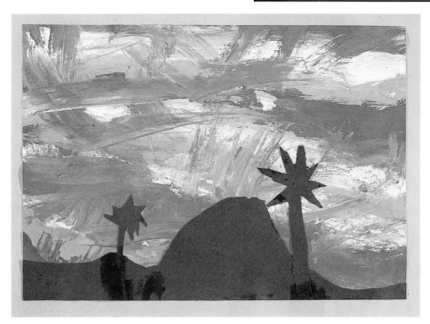

Sunset sky

You will need:

Large piece of paper for background

Black paper, same width as background

Ready-mixed paints in yellow, red and white—thickened with glue

Large brushes and glue spreaders

Scissors and glue

Method:

1. Discuss silhouettes and shapes seen at sunset.

2. Apply paint thickly in stripes across the page with a large brush.

3. While the paint is wet, use glue spreader to blend the stripes of colour in any direction. Allow this to dry.

4. On the black paper draw a skyline, e.g. islands, trees or buildings etc. Cut this out and glue onto the coloured background.

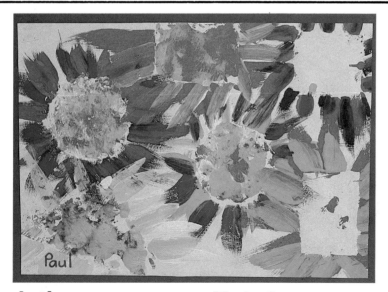

Flickbrush painting

You will need:

White paper for background

Ready mixed paint—primary colours

Cardboard

Scissors and large brushes

Method:

1. Cut out simple cardboard shapes.

2. Place a cardboard shape on the paper, hold it firmly and with a well loaded brush flick outwards all around the shape.

3. Move the shape around the page and repeat with different colours.

Printing and painting

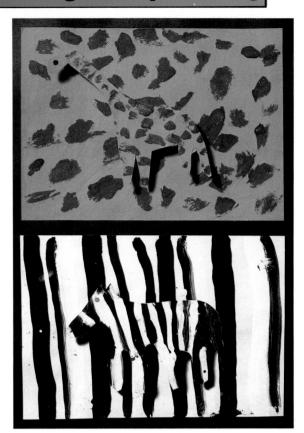

Animal illusions

You will need:

Paper for background

Small pieces of paper to make the animal

Pictures of wild animals

Paint in appropriate colours

Paint brushes—thick and thin

A matchbox or stiff card.

Scissors and glue.

Method:

1. Look carefully at pictures to observe animal shapes and markings.
2. Draw an animal on the smaller piece of paper and cut it out.
3. Using a thick brush, paint the background paper with the animal markings. Using the thin brush repeat these markings on the animal shape.
4. Glue the animal onto the matchbox and then onto the background.

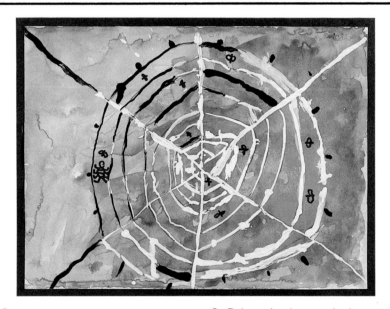

Spider's web

You will need:

Light coloured paper for background

Coloured paints in light and dark greens, black and white

Brushes—thick and thin

Method:

1. Demonstrate how a spider's web is formed.
2. Draw a spider's web on the background with spokes touching the edges of the paper.
3. Paint a background of greens going from light to dark across the page. Leave to dry.
4. Use a fine brush to paint the web in dark and light colours to contrast with the background. (e.g. black paint on light parts of background, and white on the dark areas.)

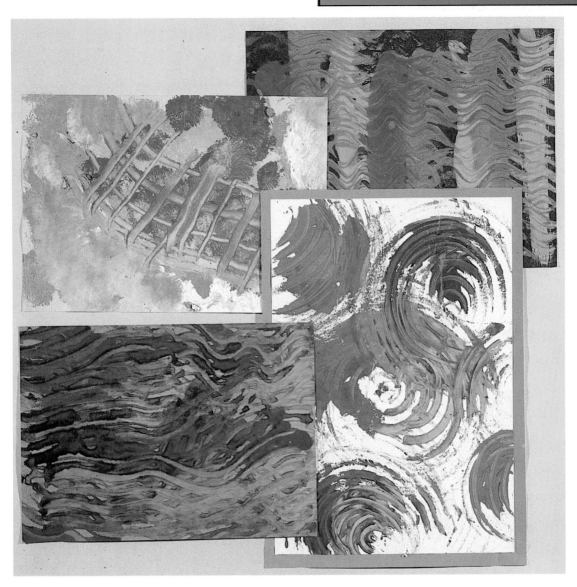

Comb painting

You will need:

Paper for background

Paint in various colours—can be thickened with wallpaper paste for more texture

Large brushes

Stiff cardboard for comb

Scissors

Method:

1. Make a comb from cardboard by cutting teeth shapes.

2. Drop paint on to the paper with a brush.
3. Spread paint around using the comb.
4. Experiment by twisting or sweeping the comb to create different effects.

Note:

● This technique is useful for making hair, trees, fire and waves.

● In appropriate colours it makes a good underwater background.

Printing and painting

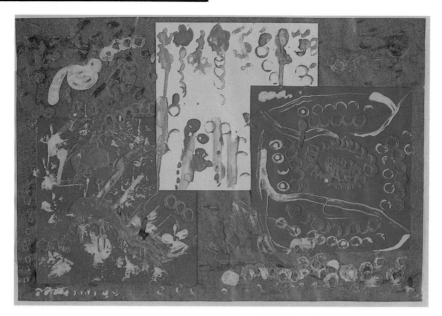

Painting rolls

You will need:

Paper for background

Black and several colours of ink or paint in small containers

Scraps of paper for rolling

Adhesive tape and thin drinking straws

Container of water

Method:

1. Roll the paper tightly to make tubes of varying thicknesses and fasten with tape.
2. Dip the paper rolls into the ink or paint, and use like a paintbrush to make a picture.
3. Dip tubes into the water and use as a paintbrush to achieve different effects.
4. Some tubes can be fringed at one end to vary the effect.
5. Use straws to paint fine detail.

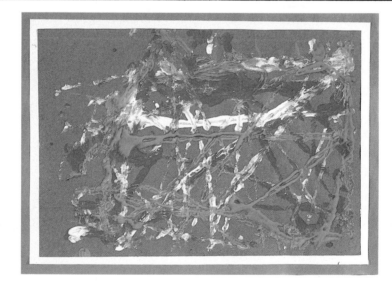

Ball painting

You will need:

Sheet of paper

Rubber or plastic balls—small/medium

Large box or tray

Paint in various colours in bowls

Large spoons—slotted if possible

Bowl of clean water

Method:

1. Put sheet of paper in bottom of the box or tray.
2. Place balls in the bowls, then spoon balls of different colours into the box or tray. Tilt this to roll the balls and form the pattern.
3. Remove balls with spoon and wash in bowl of water.
4. Repeat with other colours.

This section shows how everyday objects can be used as a source of inspiration for art and language. Observing common objects closely and considering their potential provides endless art ideas. Thus stimulated, children are then motivated to talk and write.

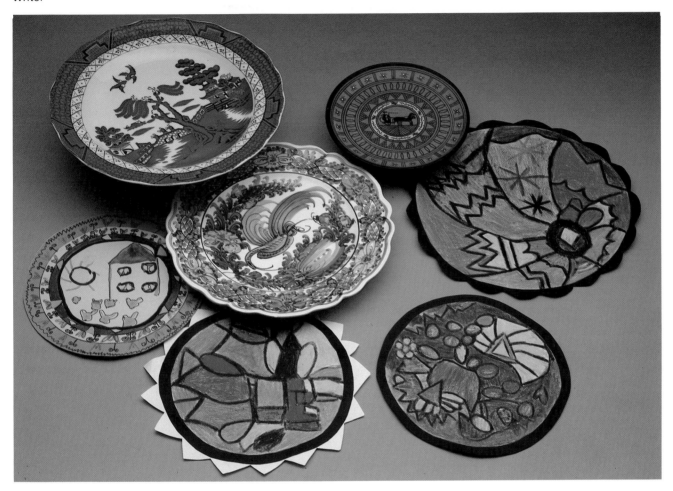

Plates

1. Look at various plates and discuss their design and pattern. Cut circles or other shapes from paper. Starting anywhere on the "plate", draw a simple shape, e.g. triangle. Extend the pattern from this shape. Rub hard with coloured crayons to fill in the pattern. (If a magazine or a few thicknesses of newspaper are placed underneath the paper, it will give a bright polished effect.) Complete the pattern with thick felt-tip pens. Glue on to card. Is this plate magic? Who owns it? Where was it found? Think of other writing ideas.

2. Look at a willow pattern plate and talk about the story. Draw a circle on card. Design a border with felt-tip pens. Use pieces of gummed paper to decorate the plate and create a new story.

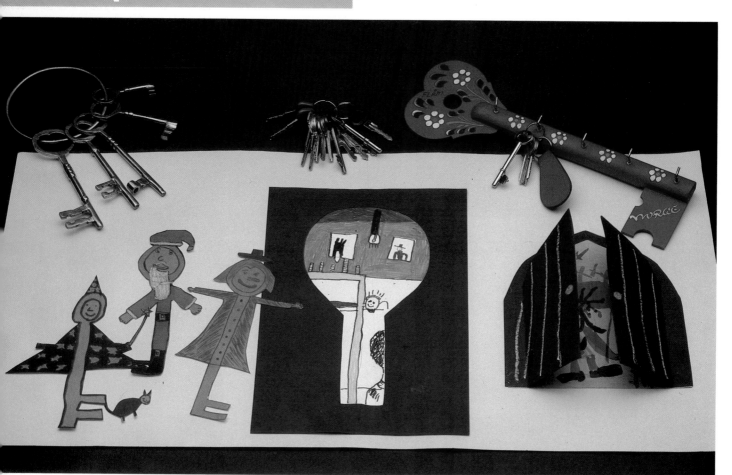

Keys

1. Key characters:

Look carefully at a variety of keys. Keeping the key shape in mind, draw a key character and talk about its personality. Cut it out and decorate it.

2. Key-hole Pictures:

Discuss key-hole shapes and imagine what can be seen through them. Remember you can only see part of a scene. Cut out a keyhole shape symmetrically from a piece of black paper and glue on to a pale background. Draw the scene in the space. Swap with someone else and write about it.

2. Behind the Door:

Cut out a doorway. Cut it down the middle so that it opens out. Make it into a picture. Write about who lives there and what is happening inside. Is it a haunted castle? A fisherman's cottage?

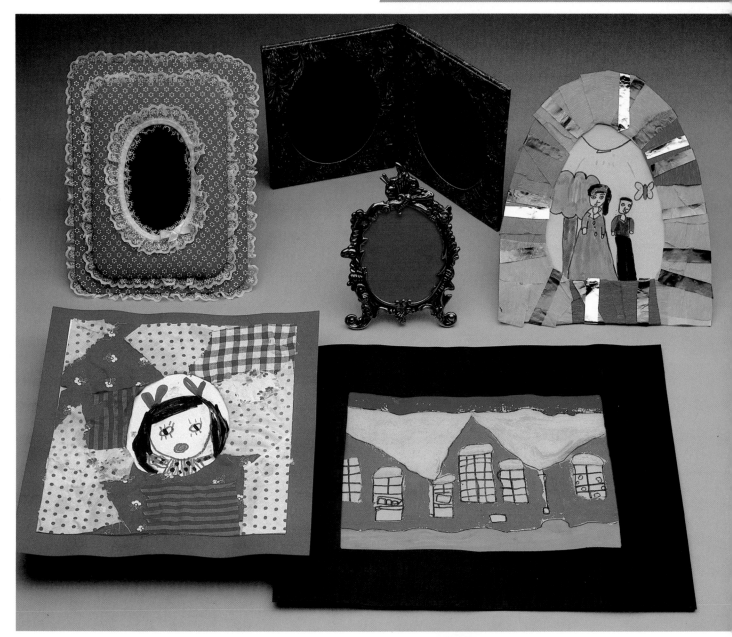

Frames

1. Using black paper, make a symmetrical frame. Glue on to a background. Make a picture, e.g. silhouette. Trim off excess paper.
 Talk about famous people, write about fictitious characters and their exploits.

2. Make a symmetrical frame from white card. Cover it with glue and wind strips of crepe paper all round. Decorate with material, gummed paper or foil. Glue on to a chosen section of a picture and trim off excess.

3. Make a large rectangular or square frame from stiff card. Hold the frame over various surfaces (perhaps in the playground or against a window). Paint or draw on a separate sheet what you see inside the frame.

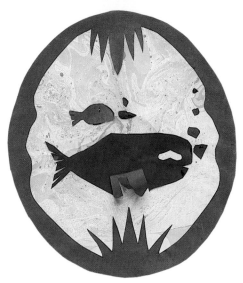

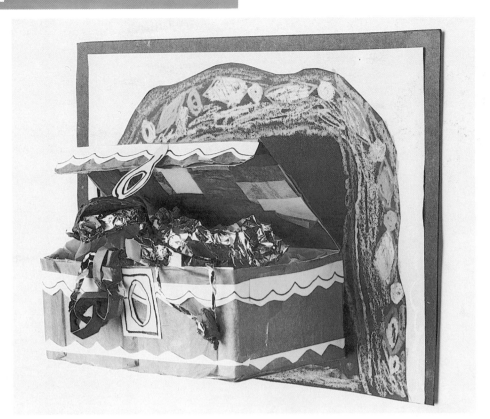

A decorated box

Look at some decorative boxes and talk about the patterns and colours. Find a small box with a lid and paint or cover it with tissue paper, inside and outside. Cut out a cave shape and glue on to a stiff background. Glue the box on to the background and fill with jewellery made from brightly coloured scraps. Prop the lid open with a straw and hang on the wall.

Two-dimensional Treasure Chest

Cut four black strips and decorate them with gold and silver crayons. Glue them on to a background to form a rectangle. Make a lid to fit over the space and decorate in the same way. Attach it along the top. Draw or make treasure from brightly coloured scraps to go inside. Hang it on the wall.

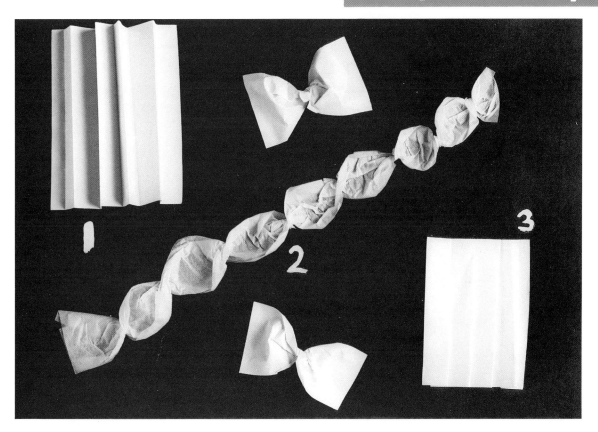

1. Fan folding—useful as bodies, legs, fences
2. Twisting—streamers, bows
3. Pleating—curtains, clothes
4. Quilling—animals, faces
5. Rolling and splitting—trees, animals
6. Spiralling—snails, hair

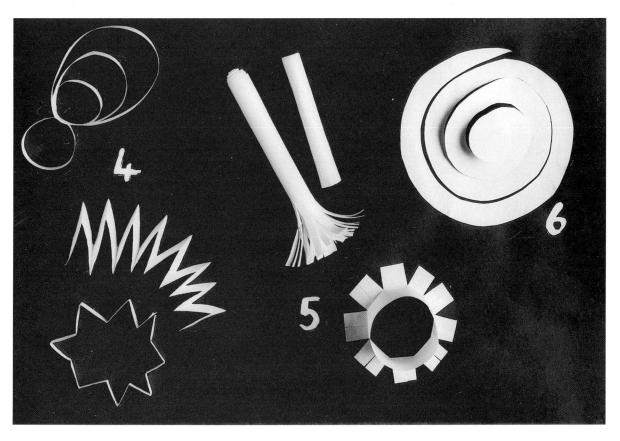

Drawing techniques

Here are a few hints to help children draw an outline large enough to fill a page without using a template.

STAGE 1: Touch one edge of a page and draw a dot anywhere along it. Join the dots with lines to make a large shape. (Suitable for drawing a fish, a kite, a mountain etc.)

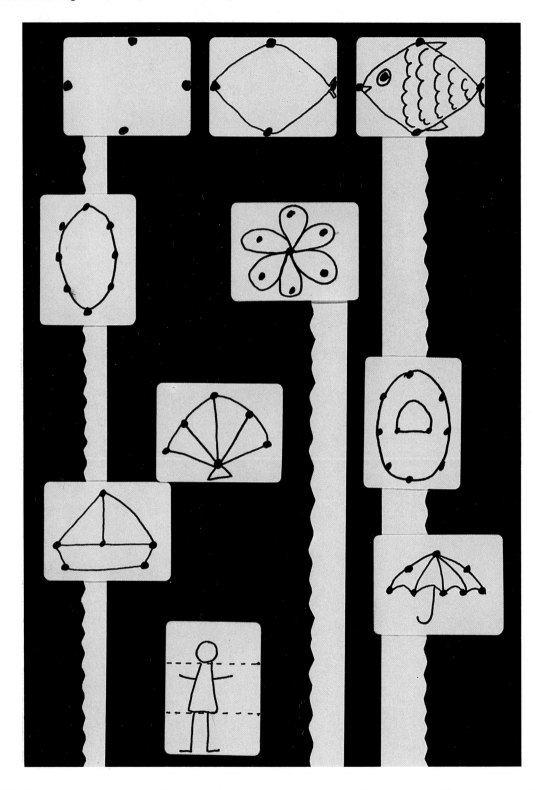

STAGE 2: Draw dots on a page a short distance from each edge. Join these to make a specific shape, e.g. a flower, an oval, a fan, a basket etc.

Note:
● To draw a figure, fold the page in three. Draw the head on the top fold, body in the middle, and legs at the bottom.

(a) Fold the pictures in half and cut patterns around the open edge.

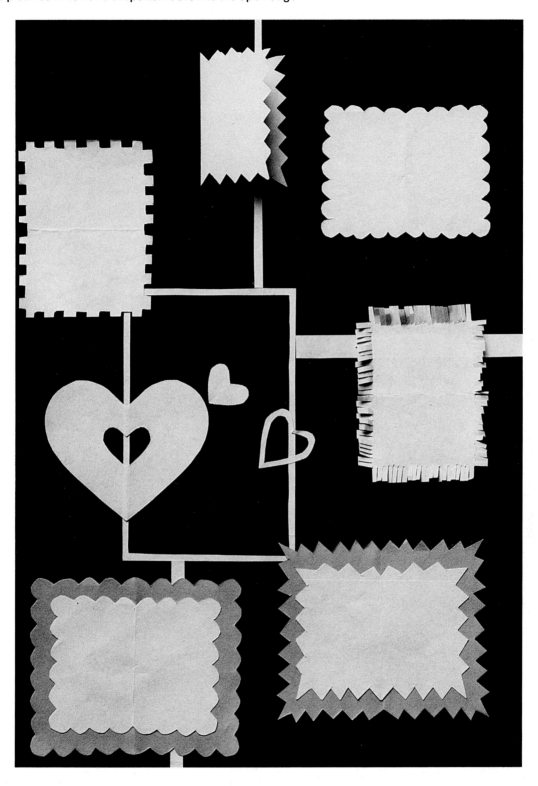

(b) Double mount the pictures and repeat the pattern around the mount.

For further details

of other Belair Publications
please write to:
Belair Publications Ltd.,
P.O. BOX 12,
TWICKENHAM TW1 2QL,
England.

For sales and distribution outside America:

Folens Publishers, Albert House, Apex Business Centre,

Boscombe Road, Dunstable, Beds., LU5 4RL, England

BELAIR PUBLICATIONS USA

116 Corporation Way

Venice, Florida 34292